WORKS 11

John T Davis

GANDON EDITIONS

WORKS 11 – JOHN T DAVIS

Published as part of Gandon Editions
WORKS series on the contemporary
visual arts in Ireland (listed on p32).

ISBN 0946641 323

Editor John O'Regan

Asst Editor Nicola Dearey
Design John O'Regan
 © Gandon
Photography John T Davis et al
Production Gandon
Printing Betaprint, Dublin

Distributed by Gandon and its
overseas agents.

GANDON EDITIONS LTD

*Gandon Editions gratefully
acknowledges the grant-aiding of
this book as part of the third set of
four titles in the WORKS series by:*

*The Arts Council /
An Chomhairle Ealaíon*

and the support of:

*Gandon Foundation
Betaprint, Dublin*

WORKS 11 JOHN T DAVIS

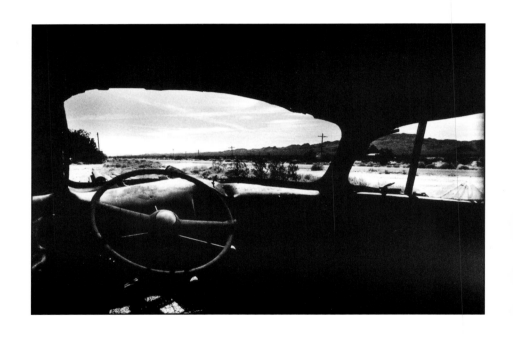

Route 66
1985

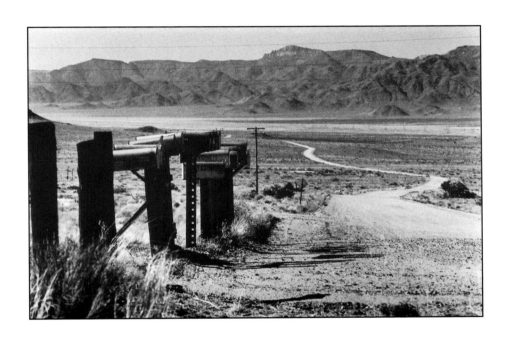

Route 66
1985 Mojave Desert

JOHN T DAVIS
in conversation with John O'Regan

John O'Regan – What influenced you to become a film-maker?

John T Davis – It started, I guess, by going to art college in 1967. I remember it so vividly because Woodie Guthrie died in that year. I used to look like an old Dust Bowl farmer because of my obsession with all that, and *The Grapes of Wrath* and Steinbeck. I came up right in the middle of the hard-core sixties and we know what we were all into in the sixties. I'm very glad that I spent those four years going to art college and experienced all that stuff. It was exciting. The experiences – psychedelia and so forth – have lasted a long time since.

Were there any more filmic influences?

I'm not suggesting it was in my family, but my uncle, John McBride Neill, a great man, was a cinema architect and designed cinemas all around the country. He did the wonderful Tonic cinema in Bangor and cinemas in Belfast. By 1974 I had long finished art college and I'd got my emigration papers to go to Canada with Charlie Whisker when my uncle died. He entrusted to me a house in Holywood [Co Down] which has been a kind of an energy centre for me because I grew up as much in that house as I did with my parents.

In his will he left me an 8mm camera. Now, I felt a certain obligation to at least play with this thing. I got a load of out-of-date Single 8 stock and started to experiment with it and I found it totally inspired me. It gave me another direction, because painting wasn't doing anything at all for me. I was heavily into music, images, and Andy Warhol and the films that he was doing. I saw Donn Pennebaker film Bob Dylan here on the streets of Belfast in 1966. I was a Dylan freak then, and suppose still am, but there was Pennebaker doing it with an aul' CP-16 on his shoulder. I thought, 'I want to do that'. I was just so enthusiastic. My friends would gather round, we'd get some wine and shoot this kind of bondage sequence on 8mm with no sound. Those were precious days looking back on them. After a year of doing that and ending up with this half-hour piece of film, I decided to take it seriously. This was going to be the type of art through which I could explore my life. And although I did interviews with with RTE, BBC and UTV,

I never really wanted to work with them. I bought as much second-hand 16mm equipment as I could afford and really started from that point. That would have been '75.

What were your college paintings like?

A lot my work at the end of art college was to do with surrealism and psychedelia, many of the paintings were photographically-based. I did my thesis on a jumbo jet – I got some wonderful photographs and used these as abstracted images. There were bits of poetry on the paintings as well – we were all into that. It came out of Lou Reid, Andy Warhol, Bob Dylan and also the pop art at the time. The major painting that I had in the diploma show was a pale blue canvas about 11ft x 14, and going maybe two-thirds of the way across it was a 747 vapour-trail going west.

To America. So that was prophetic in its own way! With your art college background, do you use elaborately drawn storyboards?

I very rarely use a storyboard in a traditional sense. There are times when we've had only one day to shoot a pop video and you've got multi-camera shots and you've got to get the different angles and the sync right, and so on. I did it with *Mr Twilight* – it was the first video I'd done and I couldn't blow it or the budget would have gone out the damned window. I don't use storyboards as such, but I draw all the little sequences across a wall to see it in one go and make some kind of connection between it all. I do that with every film I make, either before or after I have it in the can.

Your first success was Shell Shock Rock, *in 1978, which dealt with the explosion of punk music in Belfast.*

Well, yes. It was the first film I suppose that anybody took notice of and that I was satisfied with. There were experimental things prior to that – one called *Between the Line* was screened in Dublin and got some reaction. It dealt with this line between sanity and insanity, what it is and how easily you can go over. And while *Shell Shock* was being conceived and made, I formed a company with Alwyn James called Holywood Films and we did industrial films. *Shell Shock* was banned by the Cork Film Festival – in their conservatism, they didn't think it was technically up to standard. However, it was shown because myself, Terry Hooley, Ross Graham and two punk bands made the effort. We hired a hall, and a thousand kids came along to watch the film and the bands. We had a press screening and we were in every newspaper and the Festival authorities eventually retracted their statement.

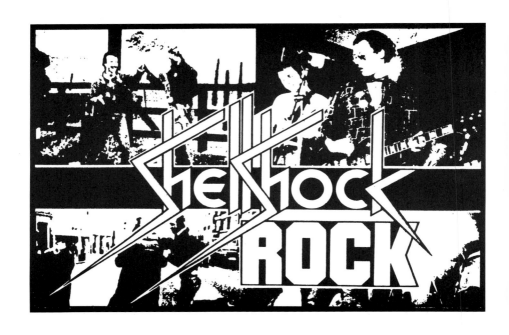

Shell Shock Rock
1978

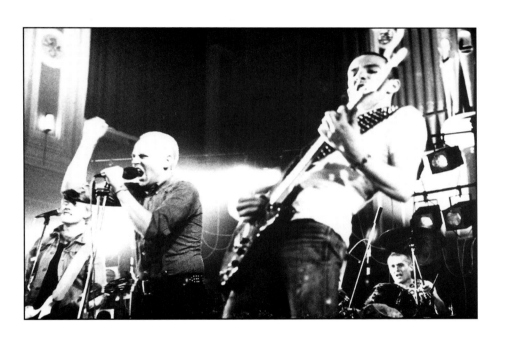

Self-Conscious Over You
1981 The Outcasts at the Ulster Hall

How did Shell Shock Rock *come about? Were you closely associated with the young bands around Belfast at the time?*

No, I wasn't, because my musical background then was more like Dylan, Springsteen and underground American stuff. One afternoon, I was with Alwyn James when he was taking photographs of Stiff Little Fingers, and I thought, 'Fuck me, is this happening up the road here and I don't know about it.' I saw that this was a reaction to the shit that was going down here, a positive thing in the midst of the Troubles when the kids didn't know anything except violence and bombing. It was great to think that here were kids who wanted to be punks instead of getting involved. *Shell Shock Rock* was the outcome of all that.

The film gives the impression of being unstructured and impressionistic, avoiding weighty camera work.

The style of it was dictated by the nature of the music and the subject-matter. And so, it's a raw and rough piece of camerawork and editing. Now, having said that, if I could go back in time to *Shell Shock* with the skills that I have now, I couldn't make it like that – in ways I've become too sophisticated.

It won the Silver Award at the International Festival of Film and TV in New York, and after that you spent some time in the States.

I hadn't been to America prior to that, and when *Shell Shock* won the award, it was a kick in the ass to go there. So I went, in 1979, and I hardly knew a sinner. I spent nine months in New York City, after intending to go for a month. I lived on the Lower East Side, in the underground rock'n'roll culture. I just fitted into it. I sold the film for art-house distribution across America and to cable networks, so it got out there ... Years later, I met someone in an electrical repair shop in Missouri who'd seen it; he said to me: 'You've got an accent the same as a guy I saw on TV the other night.' Oh really? It's just bizarre.

So, a lot of absorbing New York culture but any film-making or work in that direction?

I worked in and around film-makers all the time. I suppose they were the people I gravitated to. And rock'n'roll. The Stimulators introduced me to Allen Ginsburg, and I spent some time living in his apartment. That was amazing for me, that kind of centre of energy looking at his influences, reading his poetry and lying out on the fire escape listening to him read his work. I made a little

film in New York called *Protex Hurrah*, featuring the band Protex who had appeared in *Shell Shock*. The film's about St Patrick's Day in New York and later on there's a gig, that's about it. For me it meant something, because here was this little band, a bunch of kids that I knew two years ago, and there they were at the mercy of New York City. It had to be documented.

When I came home, I did another film which was like the wind-up of the punk deal as I knew it, called *Self-Conscious Over You* in 1981. Basically it's a concert shot in the Ulster Hall with The Outcasts and Terry and the Terrors. The concert had its origins in Good Vibrations going bankrupt and Terry having a benefit concert to try and keep it going a bit longer. In many ways it documented the end of an era in Belfast.

And then came Route 66.

The idea for *Route 66* came to me going up the Empire State Building while I was living in New York. I'd wanted to make a film about middle America, and Route 66 seemed to be the symbol to hang the whole thing on. It is 2,000 miles from Chicago to Los Angeles, and embodies all this shit that I wanted to talk about. I'd read all that stuff like *On The Road* [Jack Kerouac, 1957] in the psychedelic days at art college. Route 66 was 'like a dump-truck', as Dylan says, 'to unload your head'. You know that one? I feel so close to that film; it said everything I'd wanted to say at the time. It was the realisation of a dream, and it took a long time before another film came out of me.

Your Route 66 *wasn't about Americana or the more glamourous ages of America. Instead it showed the underbelly and the lost souls of middle America.*

I think it's a refreshing look at America because it goes beyond the TV shows and is more in keeping with that aspect of life that kind of turns me on. It's about the underdog, the broken people, the fallen people. It's a more truthful picture of the state of the economy. The fact that homes, houses, entire towns are getting blown away by the dust in the 1980s as opposed to the 1930s, it's still happening. Depression. You know, what is progress? Progress is having an Interstate come along and take your livelihood away.

You go as someone who's been influenced by all this stuff. Like, *The Last Picture Show* [Peter Bogdanovich, 1971] was very important to me. It's a film about relationships and what happens in some small town in Texas, and this happens in every small town

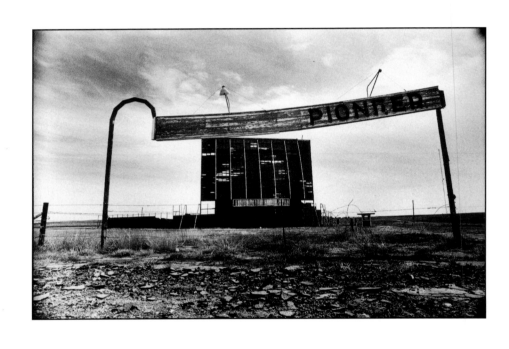

Route 66
1985 Pioneer Drive-In, Shamrock, Texas

Route 66
1985

whether in Texas or Ireland. *Route 66* also allowed me to use songs which were close to the culture – *I Wish A Buck Was Still Silver* – you know that one? And coke was still cola and a joint was a bad place. Feelings of wanting to escape, which also come across in *Hobo*; the romanticism of the West, the idea of this huge, lawless land, all of that kind of fantasy which is something that just takes my heart with it and I can't really explain why.

There's an oblique sort of political comment in the film on the state of America.

It's just so fucking obvious when you drive across America that the place is falling to pieces, and in the cities it's worse. God save us! It's a hell-hole in some of those inner cities. But there's a kind of pride which people out in the West have for their land, not in a political sense, it's just the magnitude and grandeur of the country they have a pride in. They wish that Los Angeles and New York would fall into the oceans.

There's quite a painterly feel to the film – it recalls the townscapes of Edward Hopper and the landscapes of Andrew Wyeth.

I was very conscious of all those other influences when I was out filming. You're there as an artist and you're trying to get that one shot that just says it every time, and you've all these Dust Bowl stereotype images in your brain from years before. You're not trying to repeat that but you're trying to add to it.

There is a fascination with religion in your work. Did American fundamentalism open your eyes to the religious situation at home?

Yes, it certainly did. I came across a place in Diggins, Missouri run by a character called Brother Harry who was a Vietnam vet. He'd cracked in Vietnam, seen the Lord and had come back to preach real fire and brimstone to this country community in the Ozark Mountains. They were hullabalooing and going crazy and hallelujahing and running around the exterior of the church getting into trances. I was shit-scared. I had a tape recorder up my sleeve and I hoped to God they wouldn't catch me. And then you see that on the street corners in Belfast and you wonder ...

When you returned from America you started getting in under the skin and the psyche of Northern Ireland.

After *Route 66*, I worked for other people here including DBA, which allowed me the time to develop other ideas. I could see a

great similarity between this country and the Bible Belt, where there's a church on every corner. I wanted to make some statement about this country and the country that holds my fantasies.

Power in the Blood and *Dust on the Bible* are really one body of work from which two films came. The street-preachers, to me, are a symbol of Belfast, the fundamentalist point of view being central. You can listen to a preacher in Cornmarket on a Saturday afternoon here, or see Paisley standing in front of City Hall on a Friday at lunch-time. I've been up in Stormont, shooting news, when Paisley has started talking about the Bible – in the middle of a press conference! The problem is that one-track narrowness that's best described in the slogan 'Ulster Says No'. It just shows the attitude of some people – from fundamentalist religion right through to politics. That nihilistic attitude, 'we will not change' has torn Northern Ireland apart.

It's important to make a film about your own country and find out where you stand in relation to all this. I'm afraid I use my films to live out fantasies, or to live things through other peoples' lives. I'm trying to find out because I'm of this stock here, whether I like it or not. What is it that makes these people tick, what's behind it? And also being fascinated by the madness in their eyes and as a projection of the madness in this country. I saw it also in Preacher Casey in *The Grapes of Wrath.* There's a madness in his eye that you see in the preachers on the streets of Belfast. That image symbolised what I was trying to say about the similarities between Ireland and America. The whole thing is like in one big vision.

Country singer Vernon Oxford features in Power in the Blood.

I saw a flyer saying that he was playing the Busman's Mission in Lurgan, and I thought, 'Ah fuck, it sounds wonderful, I'll have to go down here, I'm going to take a camera.' I knew his music a long time before I made the film. Vernon had lived a reckless existence, but then turned preacher. I was so taken by him, so taken because I understood him as a man, what he'd been through, his music – I could relate to him. There he was telling me about Jesus and I believed him. A prisoner in the Maze, Wilfie Cummings, had made him a music-box that played *Amazing Grace* and Vernon went to see him. There was this relationship building up and that's when *Power in the Blood* came about.

Heart on the Line, *your film on country song-writers, followed this*.

Yes, it came after a meeting in Dublin with Harlan Howard. He was

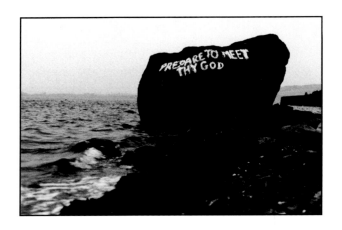

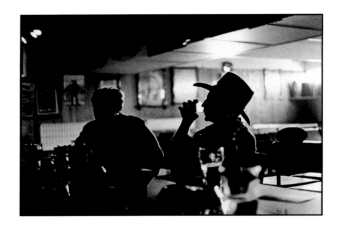

Dust on the Bible 1989 Co Down coast
Power in the Blood 1989 Vernon Oxford in bar

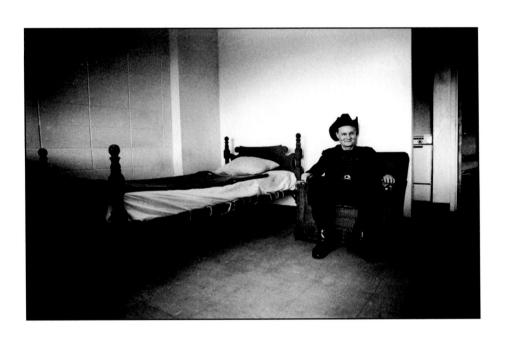

Heart on the Line
1990 Junior Lee Farrell, Nashville, Tennessee

over with Nancy Griffiths to do a spot on RTE. I'd been listening to his songs all my life and thought, I want to give him something of myself since he'd given me so much of his music. That night, I showed him *Route 66* in a room in Blooms Hotel. At the end of watching the film he had a tear in his eye because he'd done the damned trip, he'd gone out to California to try and make a buck – an orphan kid from Detroit – he'd gone down 66, got a job in a factory, sent songs to Nashville and eventually got picked up, and drove back to Nashville in a Cadillac. Success story.

Like Route 66, *your film* Hobo *is another road movie, albeit a rail-road movie.*

Well, given my background, the subject-matter isn't surprising ... I knew all the railroad songs, Jimmy Rodgers, Woodie Guthrie and the blues, and Credence Clearwater Revival – no rock'n'roll with-out the railroads. But it takes something to actually inspire you to do it. I had read an article by Bruce Duffy who'd been to the hobo convention, and I had a book called *Good Company* full of these wonderful pictures of hobos from ten years before. I knew that stuff was happening in the 30s and 40s, but here it was only ten years ago. I wondered was it still happening. I flew from Canada to Washington to meet Bruce. He gave me the introduction to 'Beargrease', and I decided the only way to do this was to ride the train to Seattle with him and see what it was like. I couldn't have made *Hobo* without having done that journey, lived through the dangers and fears with those people.

With its romantic escapist associations, is it not surprising that the life of the hobo hadn't been filmed in this way before?

There have been dramas which is a different thing altogether, but I don't think there's ever been a film documentary, quite simply because it is so difficult and totally illegal. It required two crews – I worked illegally, jumping the trains with the hobos, and a back-up team worked with permission from the railroad company, filming freight yards and sidings for a bogus documentary titled *Travelling America*. I had to strip down my 16mm camera and disguise it in my bed-roll ... and getting insurance for the production was next to impossible.

The film shows hobos as ordinary people who have fallen on hard times – not the stereotype that has permeated the press. What tuned you into that?

It takes a while for a stranger to walk into the 'jungle' [encamp-

ment] and have confidence – it doesn't come quickly. But having got on the train and ridden with some of these people ... it puts you through a lot of shit and at the end of the day that creates a bond. When you meet someone further down the line that you've met before, it's all the craic of the day. It's frightening to think that these men have had everything you've had – job, family, health, money – and then suddenly it's all wiped out. It's as fragile as that. It's very hard to get to know these people because they don't want to be known by the fact that they're out on the rails. They're running away either from themselves or the law or whatever it may be.

It's really a case of survival. If you go quietly through the night and nobody sees you, you're less likely to be rumbled or jack-rolled. It's a very solitary existence in many ways. At times I wished the whole thing was over, and then there would be another thousand miles to go. One time I rode the rails from Whitefish, Montana, down to Pasco and back up to Spogaloo, and went through all sorts of shit and potential violence from the home guard of the FTRA [Freight Train Riders of America] with their pick-axes and baseball bats. There are one hundred and one ways to die out on the rails every day.

There's quite a contrast in time-scales between the finely scheduled trains and endless times the hobos spend waiting.

That 'thinking time' is something that none of us are tuned into here, something we don't know how to do because of schedules in our own lives, but out there you're forced to do nothing. You wait and wait for days on end, and have to learn to cope with doing nothing – with 'thinking time'.

The subject-matter just fitted me like a glove but It was a hard bitch of a thing to do, to shoot and to edit. Hours of pictures, talking, wading through that and picking out the gems that would actually be representative of what was said. Sé Merry Doyle is a wonderful man. He edits all my films and is very instrumental in what comes out at the end of the day.

Your current project is about Atlantic Records and its contribution to popular music.

The film, called *Hip to the Tip*, is about Ahmet Ertegun and Herb Abramson and how they made the Atlantic Record Company what it was ... how it developed from a little hole-in-the-wall record label in 1947, to the multinational conglomerate of today. The film celebrates the music and its creation – many of the songs have

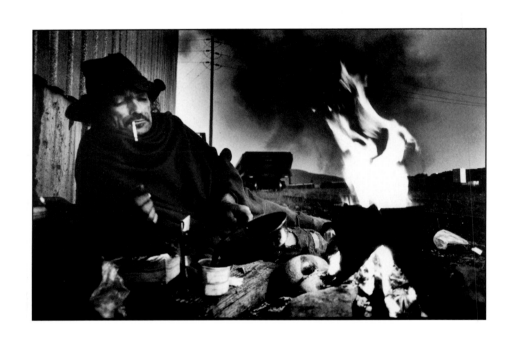

Hobo
1991 'Beargrease'

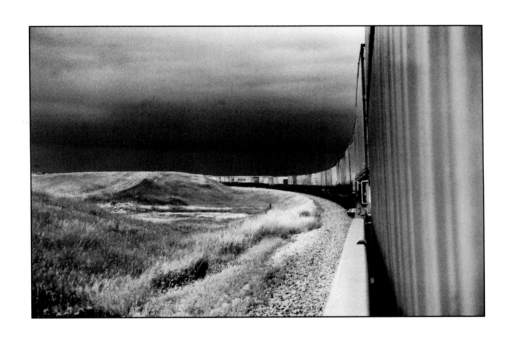

Hobo
1991

become classics embedded in our popular culture. The idea was taken to Channel 4 by Uri Fruchtmann ... they recommended he contact me, and I became involved. We had a great time even though there were loads of heavy-duty rows.

Atlantic is a major record company, with a long history and a vast output, so how did you tackle it?

The independent years from 1947 to 1974 – before they were bought over by Time-Warner – are basically what is covered in the film. The music in there is just phenomenal – early jazz, rhythm and blues, soul music, all that white rock of the early seventies, Buffalo Springfield, Led Zeppelin, Sonny and Cher ... Atlantic seem to have created the whole pattern of popular music. There are sixty-three songs in the film, including *Shake, Rattle and Roll* by Joe Turner which was the first rock'n'roll song in a way. All the memories will start flooding in when people hear the songs.

Archive footage was a horrendous nightmare amongst all the other ones. We had a couple of researchers getting that material, and then selecting it and the whole business of negotiating deals. The film was originally seventy-eight minutes, which quite clearly wasn't enough time to tell the story in – now it's two hours long. It's been tremendously complicated in all areas, from pre-production to production to post-production. Sé [Merry Doyle] played a really major role in the cutting room. But it's been worth it. At the end of the film it is quite caustic – commenting on what the record business has become, about people who worked together for twenty-five years and no longer work together, about what happens when a company becomes corporate.

What's it like being an Irish film-maker in America?

I take great pride in being Irish in America. I don't feel a stranger when I go to the United States. I mean in terms of the history of the place and what our little country has given to America. I walk round with a cowboy hat on me and I don't feel that I shouldn't do that or I can't do that. There's a whole romanticism caught up in there with it. Being Irish in America is great. I love it.

Your films are marked by a concern for the underdog, a keen interest in music, and a fascination with religion ...

I suppose you're right.

... but never sex!

It's much easier putting religion in films than sex, and if I answer questions about that, it gets me into awful trouble at home. No I don't know. Yes, you're right. I'll put it right with the next one – there's going to be loads of sex in the next one!

You're not too concerned with demarcation between documentary and drama – you have characters within the documentaries.

I don't know what my films are. I don't think of them as documentaries and they're not fiction, but there's drama in them of some description even though they're not acted. This journalistic approach to documentaries which you see on the television every night is so boring, and, unfortunately, that's what most people regard as documentary. I use the film itself to tell the story.

I can only go out and film in one way. You really only make one film in your life, or write one song or do one painting, but you keep doing it over and over again until you get to the heart of it. I use recurring thoughts, recurring images – different shots saying the same thing. There's always some sort of twilight area, a sense of longing, a sense of decay. But I try to photograph all of this as beautifully as possible to create a visual feast.

Is there an ambition there towards more conventionally 'fictional' feature films?

I love the excitement of going out there on a shoot with a certain idea in mind, and you come back with a load of colours on a palette. You go into the cutting room and you find out the best way to mix them and there's an excitement with that because it's not pre-ordained. One thing can lead you to another which you hadn't even thought of, simply by sticking two shots together. I don't think you get that in drama, in fiction. That still excites me an awful lot. To quote Pennebaker, 'I use situations that are real, but the films are imagined dreams of what really happened', and I think that's wonderful.

April 1993

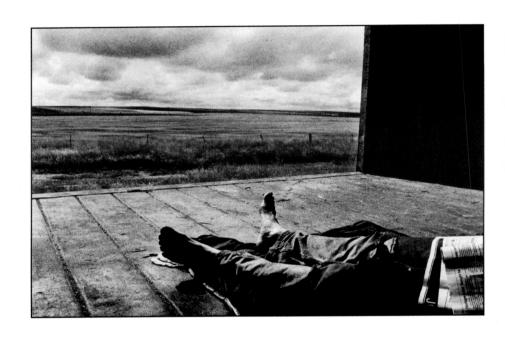

Hobo
1991

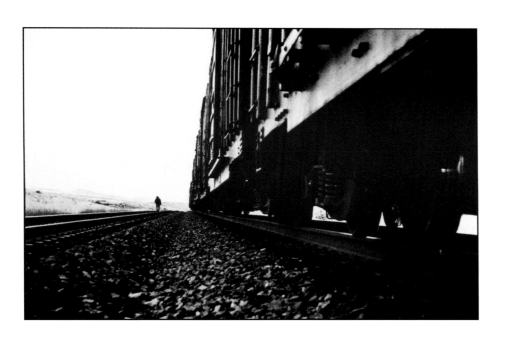

Hobo
1991

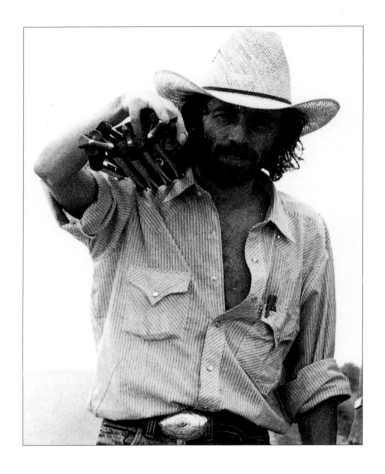

John T Davis

JOHN T DAVIS

1947 Born in Belfast
1967-71 Belfast Art College
 Lives and works in Holywood, Co Down

Filmography

1993 *Hip to the Tip – Atlantic: The Independent Years*
1991 *Hobo*
1990 *Heart on the Line*
1989 *Power in the Blood*
1989 *Dust on the Bible*
1985 *Route 66*
1981 *Self-Conscious Over You*
1980 *Protex Hurrah*
1978 *Shell Shock Rock*
1977-83 commercial/industrial films, eg *Bridging the Foyle*
1977 *Between the Line*
1975 *Transfer*

Selected Videos

1989 *Have I Told You Lately* [Van Morrison]
1987 *Heaven Can Wait* [In Tua Nua]
 Footsteps in the Sand [Delta]
1986 *Mr Twilight* [Light A Big Fire]

Festivals

1993 Edinburgh Film Festival – *Hip to the Tip*
 Oakland National Educational Film and TV Festival – *Hobo*
1992 Edinburgh Film Festival – *Hobo*
 Dublin Film Festival – all films
 Galway Film Festival – all films
 San Sebastian Film Festival
 – Young Audience Award for *Hobo*
 Amsterdam Documentary Film Festival – *Hobo*
 Leeds Film Festival – *Hobo* / *Route 66*
1989 Cork Film Festival – featured director (retrospective)
 – Award for 'a significant contribution to Irish cinema'
1986 Banff TV Festival, Canada
 – Special Jury Award for *Route 66*
1985 Dublin Film Festival – *Route 66*
1980s Celtic Film Festival – *Dust on the Bible* / *Power in the Blood* /
 Route 66
1979 Cork Film Festival – *Shell Shock Rock*
 New York Film and TV Festival
 – Silver Award for *Shell Shock Rock*

FILM CREDITS

HIP TO THE TIP – ATLANTIC: THE INDEPENDENT YEARS (1993)

Co-Directors – John T Davis, Uri Fruchtmann / *Producer* – Brendan Hughes
Photography – John T Davis / *Sound* – Tim Lay / *Editor* – Sé Merry Doyle
Commissioned by Channel 4 / 104 mins, colour, super 16

HOBO (1991)

Director – John T Davis / *Producer* – Brendan Hughes
Photography – John T Davis, David Barker
Sound – Stephen McCarthy, Deke Thompson / *Editor* – Sé Merry Doyle
Commissioned by BBC / 90 mins, colour, 16mm

HEART ON THE LINE (1990)

Director – John T Davis / *Producer* – Brendan Hughes
Photography – David Barker / *Addit. Photog.* – John T Davis, Bestor Cram
Sound – Deke Thompson, Glenn Trew / *Editor* – Sé Merry Doyle
Commissioned by Channel 4 / 61 mins, colour, 16mm

POWER IN THE BLOOD (1989)

Director – John T Davis / *Producer* – John T Davis
Photography – David Barker / *Sound* – Deke Thompson
Editor – Sé Merry Doyle
Commissioned by BBC / 76 mins, colour, 16mm

DUST ON THE BIBLE (1989)

Director – John T Davis / *Assoc. Producer* – Brendan Hughes
Photography – John T Davis / *Sound* – Deke Thompson
Editor – Sé Merry Doyle
Commissioned by Channel 4 / 52 mins, colour, 16mm

ROUTE 66 (1985)

Director – John T Davis / *Producer* – Malcolm Frazer
Photography – Peter Greenhalgh / *Sound* – Steve Phillips
Editor – David Leighton
Commissioned by Central TV / co-production Central and Iona Productions
104 mins, colour, 16mm

SELF-CONSCIOUS OVER YOU (1981)

Director / Producer – John T Davis
Photography – David Barker / *Sound* – Colin Martin, Alan Dickenson
Editor – John T Davis
Commissioned by BBC (N Ireland) / 40 mins, colour, 16mm

PROTEX HURRAH (1980)

Director / Producer – John T Davis
Photography – John T Davis, Byron Lovelace / *Sound* – Peter Shelton
Editor – John T Davis / 15 mins, colour, 16mm

SHELL SHOCK ROCK (1978)

Director / Producer – John T Davis
Photography – John T Davis, Alwyn James, Tommy McConville
Sound – Derek Booker, Mary James / *Editor* – John T Davis, Ross Graham
52 mins, colour, 16mm

BETWEEN THE LINE (1977)

Director / Producer / Photography / Sound / Editor – John T Davis
30 mins, colour, 16mm

TRANSFER (1975)

Director / Producer / Photography – John T Davis
Editor – John T Davis, Dick Sinclair / 30 mins, colour, super 8

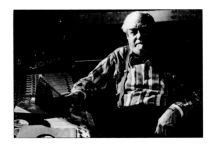

Hip to the Tip
1993 Herb Abramson, co-founder of Atlantic Records

THE WORKS SERIES

edited by John O'Regan

GANDON EDITIONS